Winslow Homer

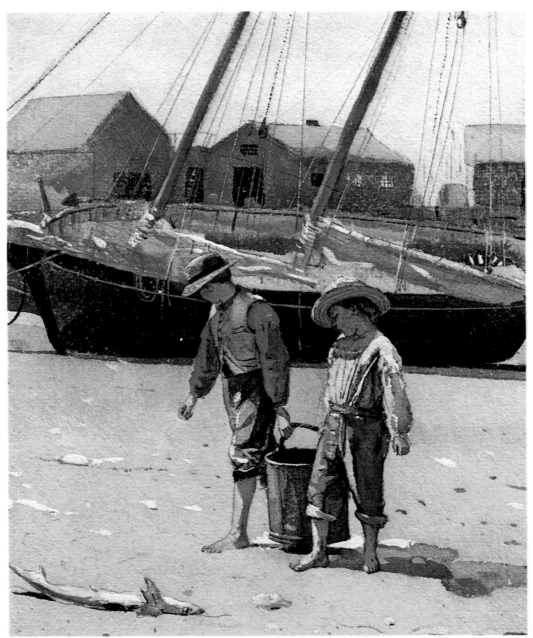

Detail from Plate VIII

Funk & Wagnalls, Inc., New York

JOHN WILMERDING

LEON E. WILLIAMS PROFESSOR OF ART,
DARTMOUTH COLLEGE

Winslow Homer
1836–1910

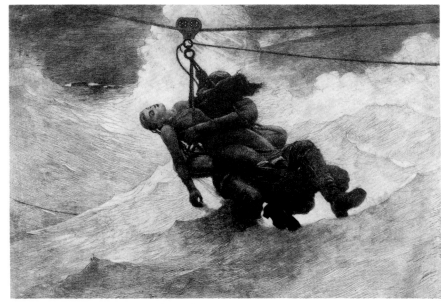

1. THE LIFE LINE (1884)
Metropolitan Museum of Art, New York
(Harris Brisbane Dick Fund)

Winslow Homer was born a New England Yankee in Boston on February 24, 1836, and remained one for the rest of his life. His family had long been engaged in commerce on the sea. Life along the coast, whether at Gloucester, Massachusetts; Tynemouth, England; or Cape Elizabeth, Maine, would deeply impress and inspire Homer's creative output. When still a child, Homer's family moved out to Cambridge, where he evidently acquired his first taste for the rural countryside. Not following his older brother Charles to Harvard College, Winslow preferred to take up drawing, and in late 1854 his father arranged for him to be apprenticed to John H. Bufford, proprietor of Boston's foremost lithographic firm in that day.

Homer's artistic career began with the drudgery of executing assigned illustrations for covers of music sheets. He learned the relatively new techniques of lithography (imported into the United States shortly after its invention in Germany around the beginning of the nineteenth century), and over the next couple of years improved his technical abilities rapidly. By 1857 he was publishing in Ballou's Pictorial wood engraved illustrations of local Boston or New England scenes. These showed a lively sense of light and shadow, and a delight in characterization. In the same year his first drawings were accepted by Harper's Weekly in New York, and two years later Homer determined to move to the larger city to be at the center of its more active artistic life and commercial possibilities.

There he had his first brief formal instruction in painting from the landscape painter Frederic Rondel, and had the opportunity of meeting other

contemporaries aspiring to be artists. In 1861 he moved into the New York University building on Washington Square, where he maintained a studio for over a decade with Eastman Johnson and other artists who lived nearby. With the outbreak of the Civil War, Harper's sent Homer to the front as a correspondent. During the next few years he sent back some of his most powerful illustrations for publication. Few of his drawings were of actual combat; he preferred to draw life behind the lines or in camp. Gradually, his subjects shifted from humorous or anecdotal ones to bolder and more serious images of wounded, exhausted, or isolated soldiers.

When the war years were over, Homer, like the country, focused again on domestic life and tranquility. By now he had also completed his first oil paintings, mostly of war subjects, such as the striking Prisoners from the Front, though he also executed lovely plein-air (open air) pictures of young ladies playing croquet. Towards the end of 1866 he made his first visit abroad, a trip to Paris that lasted some nine months. He probably went primarily to see a couple of his own pictures, which had been selected for exhibition at the large Universal Exposition. While argument still continues on just what he did and saw during this period, it seems evident that he gained a certain acquaintance with contemporary French painting.

Upon his return to the United States, Homer continued his work as illustrator for various magazines and books. In the summers of the 1870's he visited the White Mountains, the Adirondacks, Gloucester, Massachusetts, and Houghton Farm in upstate New York. During this decade he began the practice of watercolor, for

the most part rather carefully executed colored drawings (e.g., A Basket of Clams, 1873). At the same time other watercolors—and the oils which resulted from them, such as Breezing Up—displayed a new freshness and exuberance, while yet other works moved towards a more delicate and introspective air. This period of his career culminated with a second trip abroad, this time to the east coast of England near Tynemouth.

Homer stayed in the little fishing village of Cullercoates for a year and a half, observing and painting watercolors of the local fishermen going about their sober way of life on the North Sea. This period marked a major turning point in his style, which now took on a broader and more serious air, looser and bolder brushwork, and more thoughtful treatments of man's struggle with the forces of nature. When he came home this time, he secluded himself for the remainder of his life on the rugged Maine coast at Prout's Neck. There he painted many of his greatest oils depicting the juxtaposed forces of life and death, among them the powerful Winter Coast and The Fox Hunt during the 1890's. Intermittent fishing and hunting trips with his brother Charles took him to the Caribbean and the Adirondacks, which also stimulated a fresh and sparkling sequence of late watercolors, as striking as any painted by an American artist. His last works, such as Kissing the Moon and Right and Left, painted in the first decade of the twentieth century, were based on familiar firsthand experiences as always, yet attained an altogether new strength of subjectivity and a degree of abstraction that foreshadowed the concerns of modern art. He died in Maine on September 29, 1910.

2. HOMEWARD BOUND (1867) *Courtesy of the Metropolitan Museum of Art, N.Y. (Harris Brisbane Dick Fund)*

*'The Sun will not rise, or set,
without my notice, and thanks.'* —WINSLOW HOMER

Winslow Homer's early graphic training in lithography and wood engraving provided all his subsequent art with a firm foundation in tonal values and strong draftsmanship. His first music sheet illustrations and wood engravings have a light-hearted touch of social observation and enjoyment of the everyday world. As such, they firmly belong to an earlier tradition of American genre painting, practiced by such artists as William Sidney Mount and George Caleb Bingham during the first half of the nineteenth century. As the Civil War unfolded and stamped itself increasingly on the consciousness of Americans, Homer's imagery became appropriately starker and his compositions stronger and more expressive. Both the stilled close-up presentation of forms and clearly silhouetted figures in *Prisoners from the Front* (Plate II) suggest interesting parallels with the writing of Walt Whitman and the war photographs of Mathew Brady.

Typical of Homer's post-war pictures is *Long Branch,*

New Jersey (Plate V), with its bright celebration of the American out-of-doors and the country's delight in the tranquil pleasures of newly popular resort life. The light palette and *plein-air* subject matter also reflect the artist's recent acquaintance with contemporary French painting. In the next few years he turned to those subjects of youth for which he is perhaps best known, such as *Snap the Whip* (Plate IV) and *Breezing Up* (Plate VI-VII). Both possess a strong sense of active linear patterns, which may derive from his seeing Japanese prints at this time. More importantly, these pictures embody the culmination of American optimism and expansiveness of spirit running so strongly through the middle decades of the century.

During the 1870's Homer also made a trip south to Virginia, which resulted in a few unusual and colorful paintings of southern life. While these possess a carefree and youthful air comparable to his northern subjects of the

same period, they exhibit a brightness of color combined with a note of thoughtfulness uncommon in Homer's work at this time. Even more striking is the prophetic sense of stillness and gravity present in the small masterpiece of 1873, *Waiting for Dad* (Plate III). Although the work is seemingly a familiar scene of casual promenading along the Gloucester shore, we are increasingly struck by the severe silhouetting of the figures, the sharp glare of sunlight, and the razor-sharp horizon, sternly marked off by the vertical forms in the foreground. Especially haunting is the awareness that each member of this family group is isolated in his own individual contemplation.

This was a crucial period in Homer's maturity, a decade during which he not only transformed the tradition of American genre painting by elevating subjects of ordinary daily life to a heroic plane, but also brought his watercolor technique to a new level of expressive accomplishment. For all of the undeniable charm of his first watercolors from the early 1870's, such as *A Basket of Clams* (Plate VIII), they display little fluidity of execution. Typically, they are composed with great care, as here the paired boys in the foreground are echoed in the two masts of the schooner behind and in the double cranes on the dock at the distant right, thus visually linking animate and inanimate forms in various parts of the painting.

Such relatively lighthearted celebrations of youth dramatically yield at the end of this decade to a new monumentality of form and subject that resulted from the English trip. Homer's oils and watercolors of the late 1870's, just before his departure, hint of the change in mood. Often he depicts young women alone in a garden or woods, picking flowers, reaching for a butterfly, reading quietly, or otherwise caught up in inner reflections and reveries. Now his handling of the bright washes is looser, more varied and facile, the forms often more broadly and

3. THE BOAT BUILDERS (1873) — *Detail*
Indianapolis Museum of Art
(Martha Dalzell Memorial Fund)

economically rendered, and the mood usually contemplative, even brooding.

In Tynemouth, Homer's young and delicate ladies are replaced by statuesque and prosaic fisherwomen, engaged in the serious business of daily chores against the bleak background of constant storms and a rugged coastal land-

4. SNAP THE WHIP (1872) *Metropolitan Museum of Art, New York (Gift of Christian A. Zabriskie, 1950)*

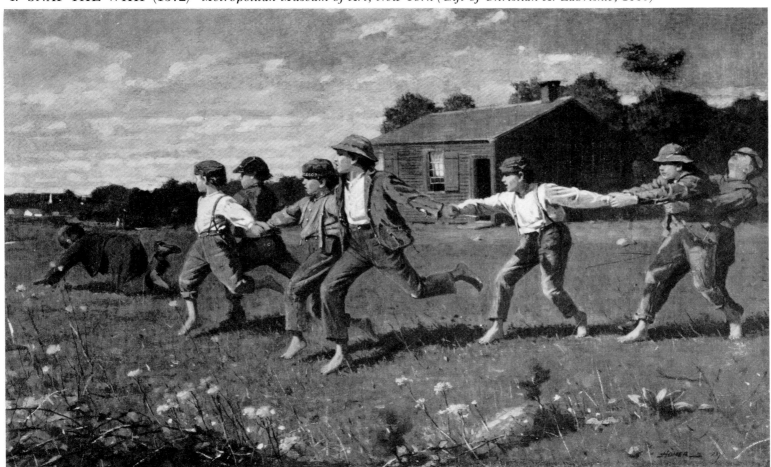

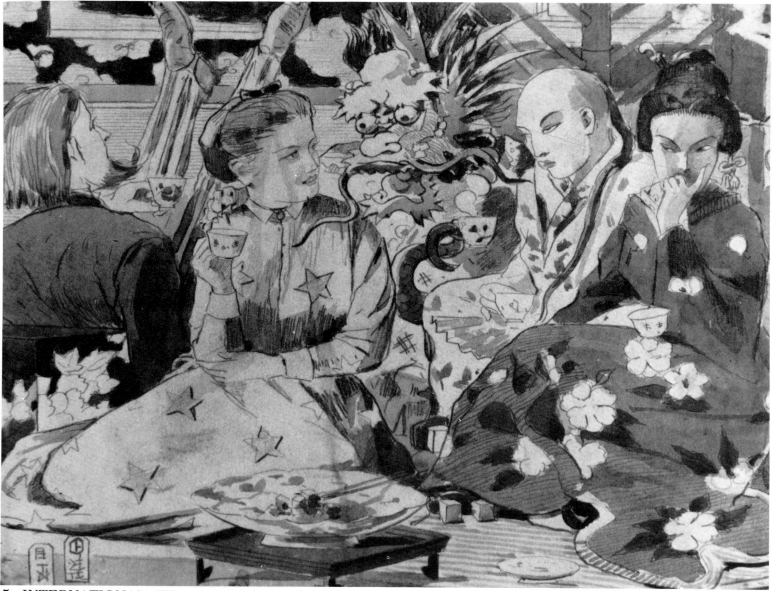

5. INTERNATIONAL TEA PARTY (c. 1874) *Cooper-Hewitt Museum, New York*

scape. Individuals seem preoccupied with their tasks, whether fishing for a livelihood or struggling against the ever-present forces of dashing waves and wind-churned clouds. The bolder composition and more monochromatic palette of *Hark! the Lark* (Plate IX) is typical of Homer's English period. It sets the stage for his return to self-imposed seclusion at his family's place at Prout's Neck, Maine, and also for the series of major works concerned with man's survival on the sea, such as *The Herring Net* (Plate X), *The Fog Warning, The Life Line* (Plate XI), and *Undertow*, which followed in the mid-1880's.

Closer now than ever to the sea, Homer often worked on the rocky shore itself, using a portable hut as an outdoor studio, always observing carefully the changing conditions and colors of sunlight and water. Intuitively, he understood that in his oils he could come to terms with the massive confrontations of waves and rocks, whereas the medium of watercolor better suited his interest in rendering the fluorescence of light and the sparkling movements of water. His later watercolors are markedly different from his first efforts of the seventies. Most apparent is the greater sense of freshness, spontaneity, and fluidity in his handling of the medium. His mature style is characterized by quick broad washes, an expressive use of the white paper itself, and an unerring sense of the major organizing shapes in a composition.

The eighties and nineties found him setting off on regular autumn and spring trips to fish and hunt with his brother. Equally he seemed to enjoy the cool landscape of the Adirondacks and Canadian woods as well as the brilliant and fragrant scenery of Florida and the Caribbean. Whether painting a deer drinking at a stream's edge or a huntsman alone in the woods (as in *Adirondack Guide*, Plate XVI), he captures an intimate yet significant corner of the natural world, wherein we gain glimpses of the processes of life and death, endurance and change.

Following in the 1890's were some of the most memorable images of Homer's career, distillations of his lifelong study of man's relationship to nature. *Winter Coast* (Plate XVII) was typical of his powerful economy: in a composition divided diagonally across the center, a solitary huntsman with dead geese slung over his shoulder makes his way along the bleak cliffs of Prout's Neck. The palette is one of stark contrasts and laden brushwork, appropriate to the drama of the season and setting. In some works of these years Homer eliminated the human figure altogether, yet we are nonetheless made to feel the ever-present struggle of life forces and the consciousness of man's place in the natural world.

Several works, such as *The Fox Hunt* (Plate XII), began as ordinary observations of outdoor life along the nearby cliffs, but acquired a compelling grandeur of vision as

Homer instilled his imagery with larger meaning and feeling. Here we observe mortality in the balance as fierce crows menace a fox caught in deep snow, ambiguously hunting and being hunted. Similarly, in *The Gulf Stream* (Plate XIII-XIV) Homer portrays an embattled figure threatened by sharks, a hostile sea, and rising squalls, yet painted with a strength of color and feeling to suggest the enduring power of man's individuality and humanity.

Like Rembrandt, Homer was an artist whose vision gained in force and depth to the end of his career, and whose last works possessed heightened originality. By the end of the nineteenth century Homer was well known and even honored, his watercolors were popular, and his oils commanded increasing prices. Living into the first decade of the new century, he continued to execute bold and fresh pictures. *Kissing the Moon* (Plate XVIII), painted in 1904, demonstrates his lingering consciousness of Japanese prints, especially the expressive possibilities of their flattened designs, color patterns, and striking juxtapositions of near and distant forms. Although the face of Homer's brother

Charles is visible at the left, the painting goes beyond the record of an ordinary shared experience to suggest an almost heroic isolation of human beings in this implacable ocean wilderness.

One of the last paintings Homer completed before his death in 1910 was *Right and Left* (Plate XIX), a compelling and haunting image. The title derives from the two blasts of a shotgun fired in the distance, hitting two wild ducks with the successive shots from each barrel. Again Homer works from personal experience, but infuses his work with a fresh, and even disturbing, power by putting the viewer in the position of the birds being fired upon. Beyond this, the painting seems to arrest in midair the motion of the two silhouetted birds, one rising and one falling. The effect is both a surprisingly modern abstraction of form and a distillation of mortality. We are made witness to an extraordinary moment suspended between life and death. This special poignancy is typical of Homer's greatest pictures, the result of a long career devoted to examining the most serious questions of both life and art.

6. EIGHT BELLS (1886) *Addison Gallery of American Art, Phillips Academy, Andover, Mass.*

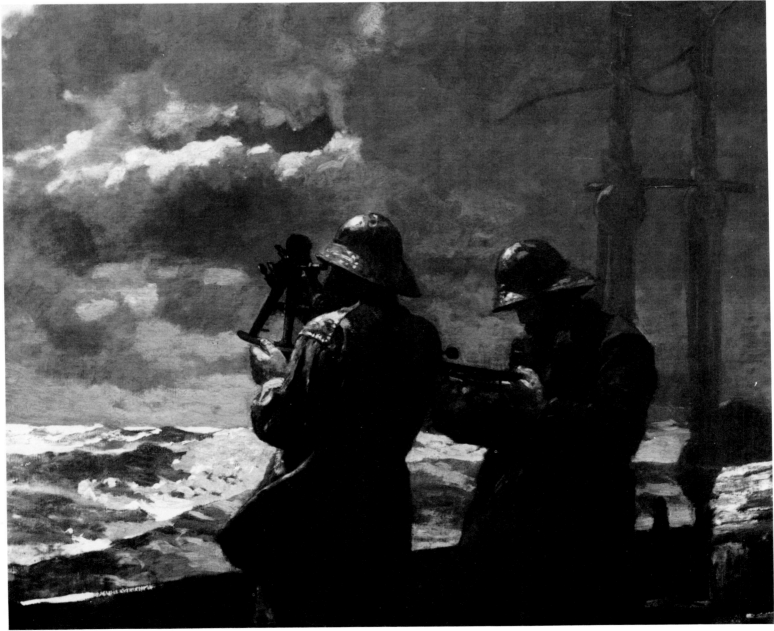

I. PITCHING QUOITS (1865)
Oil on canvas. 26¾ in. x 53¾ in.
William Hayes Fogg Art Museum, Harvard University
(Gift of Mr. and Mrs. Frederic H. Curtiss)

Civil War scenes—mostly intimate glimpses of army life behind the lines, frequently with touches of naive humor—were the subjects of Homer's first oil paintings. This cheerful canvas shows Zouaves (mercenary soldiers in the Union Army) relaxing at a campsite. The influence of the painter's early training as an illustrator is shown in the almost photographic clarity of line and focus, the faithful, detailed rendering of the colorful uniforms, the concentration on significant poses. Indeed, like many of his first oils, it was worked up in the studio from illustrations done some years earlier as a special artist for *Harper's Weekly* during the war. This may also account for a certain stiff lifelessness: the two groups of soldiers in this perfectly balanced arrangement do not really interact with one another. It is a story-telling picture built up of small excellences that nonetheless do not create a convincing whole—the work of a superior draftsman still learning to be a painter.

II. PRISONERS FROM THE FRONT (1866)
Oil on canvas. 24 in. x 38 in.
Metropolitan Museum of Art, New York
(Gift of Mrs. Frank B. Porter, 1922)

The most memorable of Homer's Civil War images, this painting makes its point with a minimum of detail. The composition is simple; nothing distracts the viewer from focusing on the main actors in the drama. Three bedraggled Confederate soldiers stand close together in a row, the directions of their right arms reinforcing the slight turning of their bodies towards the trim Union officer who faces them. The light picks out faces and hands, leaving the rest of the figure shadowed, and the fact that the horizon line curves across all of the faces strengthens the intense interlocking of gazes in this confrontation.

The guns lying on the ground imply surrender in contrast to the picture's one dominant vertical: the rifle held by the guard at the left of the captives. This dramatically posed arrangement may reflect Homer's studio reworking of one of his *Harper's Weekly* illustrations, or perhaps the influence of contemporary Civil War photographs. Nevertheless, its appeal is immediate, and its moving dignity cuts across partisan feelings. The canvas was a popular success at the 1866 National Academy of Design exhibition and established Homer's reputation.

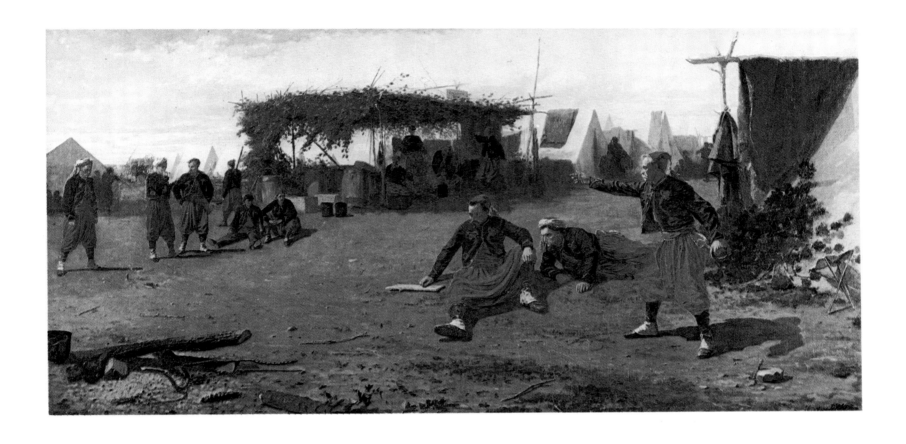

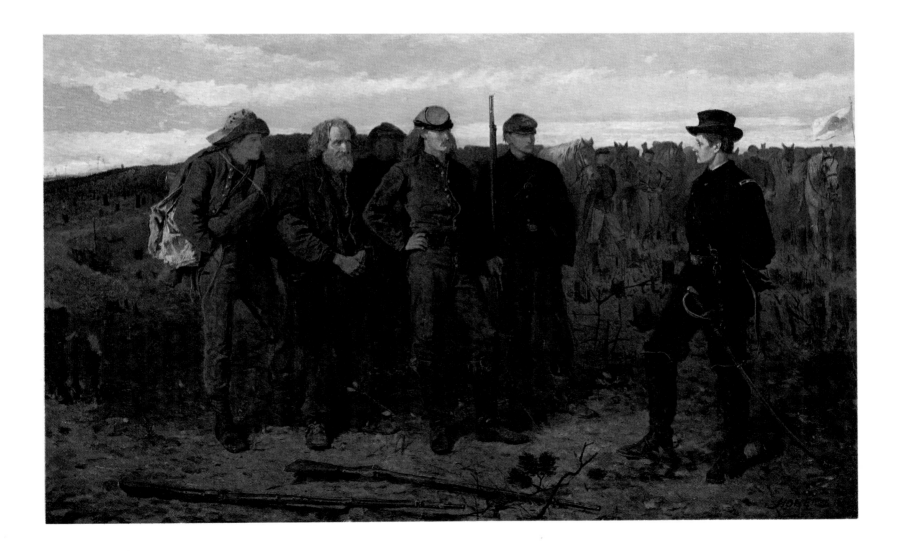

III. WAITING FOR DAD (1873)
Oil on canvas. 9¼ in. x 14 in.
Collection of Mr. and Mrs. Paul Mellon

This small painting (about the size of this page) is, paradoxically, monumental in scale. In contrast to the gay animation of most of Homer's paintings at this time, there is brooding stillness here. The figure of the mother seems carved of wood; sails are up but there is no sign of a breeze to move them. In the clear, glaring light, forms are isolated, sharply silhouetted against the sky. Like the vessels on the water and the two boats drawn up on shore, the members of this young family face away from one another. They stare off in different directions, alone with their separate thoughts, features obscured from our view. Similar treatment of interrelation among the protagonists in his paintings can be found throughout Homer's work.

The mood is one of uneasiness and anxiety, perhaps even foreboding. The very title of this unsettling picture seems to sound a deliberately ominous note.

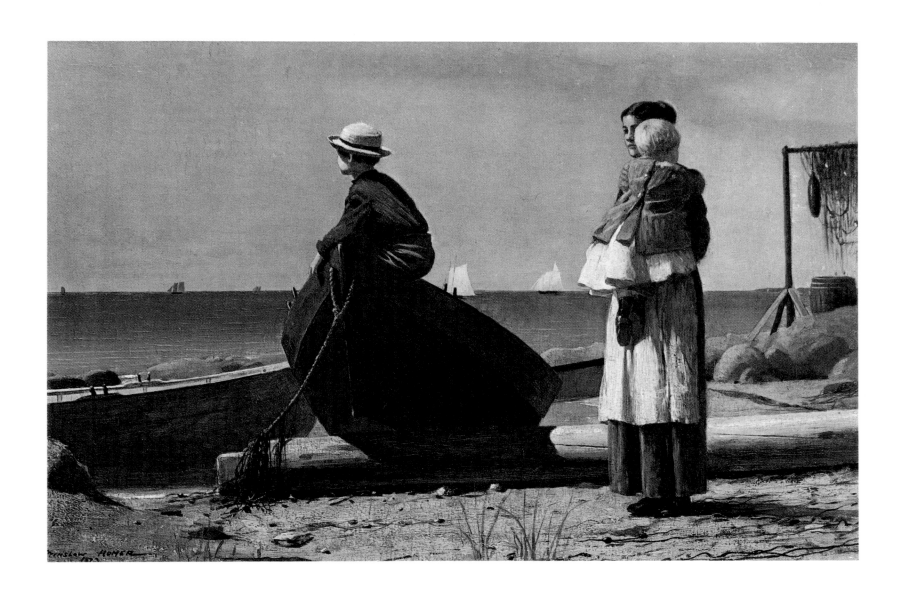

IV. SNAP THE WHIP (1872) — *Detail*
Oil on canvas. 12 in. x 20 in.
Metropolitan Museum of Art, New York
(Gift of Christian A. Zabriskie, 1950)

Rural life was one of Homer's favorite subjects in the 1870's, especially the playtime activities of country children. Never sentimental or condescending like so many American genre painters of his day, Homer is straightforward and affords a fresh, understanding glimpse of childhood joys. For the viewer of today, his paintings of the American countryside are a vigorous, nostalgic re-creation of a vanished reality.

Here, in one of his most popular and animated canvases, it is the action of the game that is the core of the painting; all incidentals that might deflect the viewer's attention have been eliminated. Thus, no onlookers are depicted, and the empty schoolhouse serves merely as a backdrop. The surging pattern of thrust and counterthrust, formed by bodies in motion and other figures checking that motion, interests the artist more than delineation of individual features or characters. Any attempt at portraiture is, in fact, avoided by the oblique angle at which we can see the figures. This strong patterning and simplicity of composition may derive from Homer's knowledge and appreciation of Japanese woodblock prints.

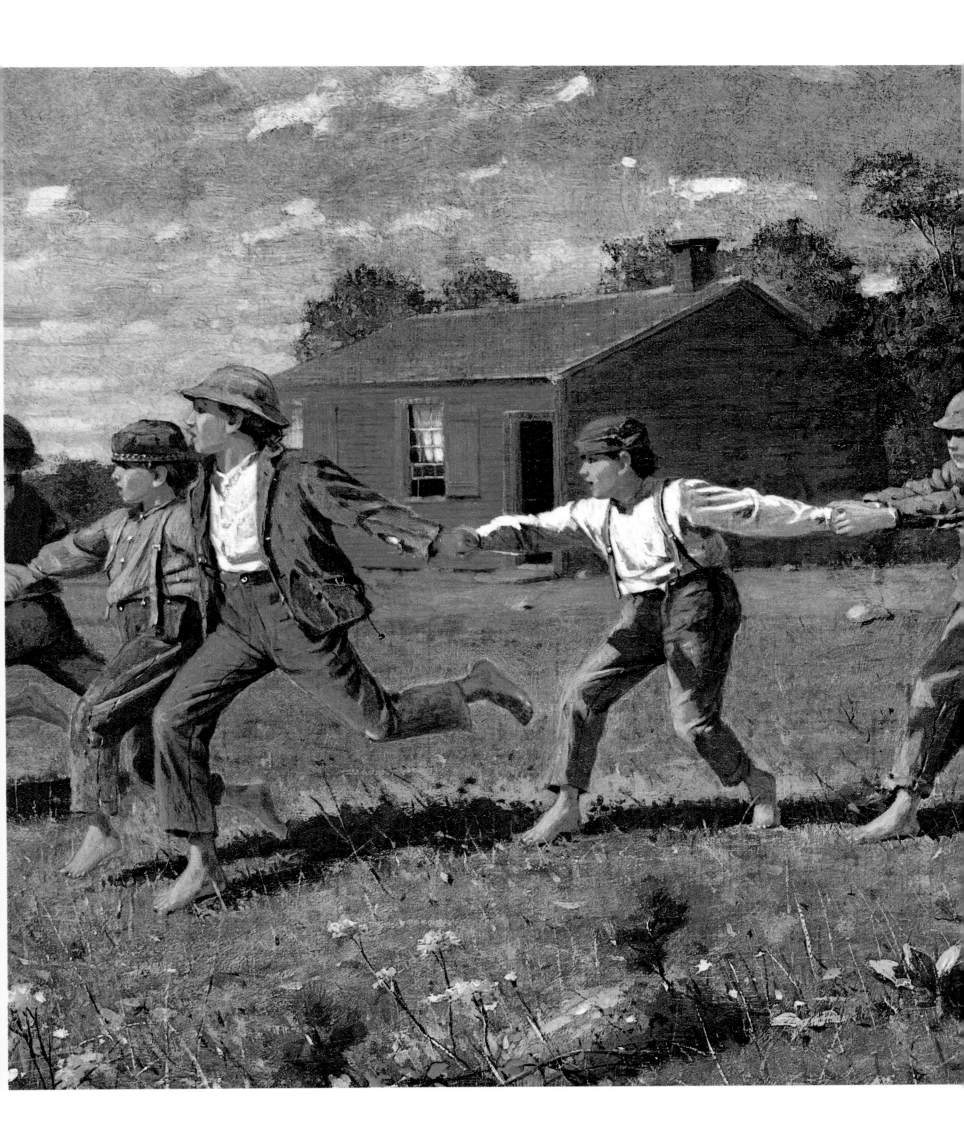

V. LONG BRANCH, NEW JERSEY (1869)
Oil on canvas. 16 in. x 21¾ in.
Museum of Fine Arts, Boston
(Charles Henry Hayden Fund)

This delightful picture is representative of a style and subject many people would not associate with Homer. It is hardly the work of a misogynous recluse, as he came to be regarded late in his life. During the 1860's and '70's he delighted in painting resort life, especially the recreations and costumes of the American girl. Vastly different from the awesome, unpeopled seascapes of his later years, the tranquil ocean and cloudless sky pictured here promise only pleasure. Human figures and habitations (the wooden bathing huts) fringe the beach and cliff, taming and domesticating nature.

After his return from France in 1868, Homer's colors became brighter, and he employed them more subtly to unify his compositions. Here, for example, the reds of the woman's hat and parasol form a triangle with the red garment hanging over the balcony at the left and the red skirt of the woman far off at the head of the steps.

Yet despite similarities in mood and open-air style, Homer seems not to have been directly influenced by his French contemporaries—the Barbizon painters and their successors, the Impressionists. His forms remain delicately but precisely drawn, their outlines not softened or dissolved by light.

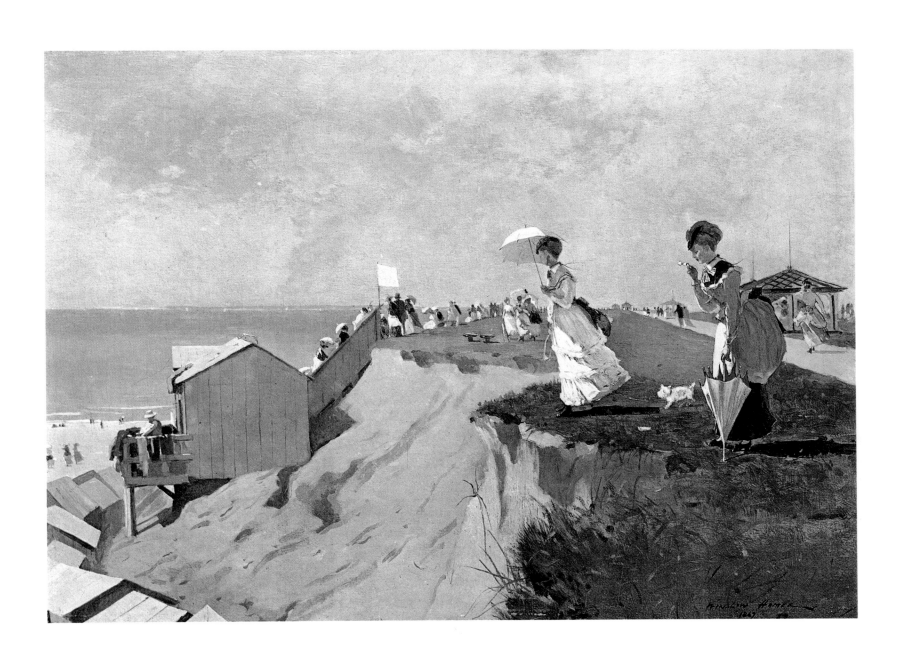

VI–VII. BREEZING UP (1876)

Oil on canvas. 24 in. x 38 in.
National Gallery of Art, Washington, D.C.
(Gift of W. L. and May T. Mellon Foundation)

From about 1873 the sea began to interest Homer, eventually becoming the dominant theme of his later years. In this painting, Homer's customary vigorous, strongly lighted rendering of joyful outdoor activities is tinged with a new seriousness. Despite their nonchalant attitudes the boys seem aware of a change brewing in weather and sea. Like the skipper intent on his maneuvers, they stare thoughtfully ahead, concerned with their separate preoccupations. The taut rope stretched horizontally from sail to stern rail—paralleled by the line of the spar above—sets off the mighty diagonal thrust of the mast. The tension between diagonal and horizontals is not only an effective compositional device but acts to underscore the psychological mood.

As usual with Homer, none of the faces is clearly delineated and one is completely turned away. But while all the figures remain generalized types, they are convincingly alive in form and movement in the context of their setting.

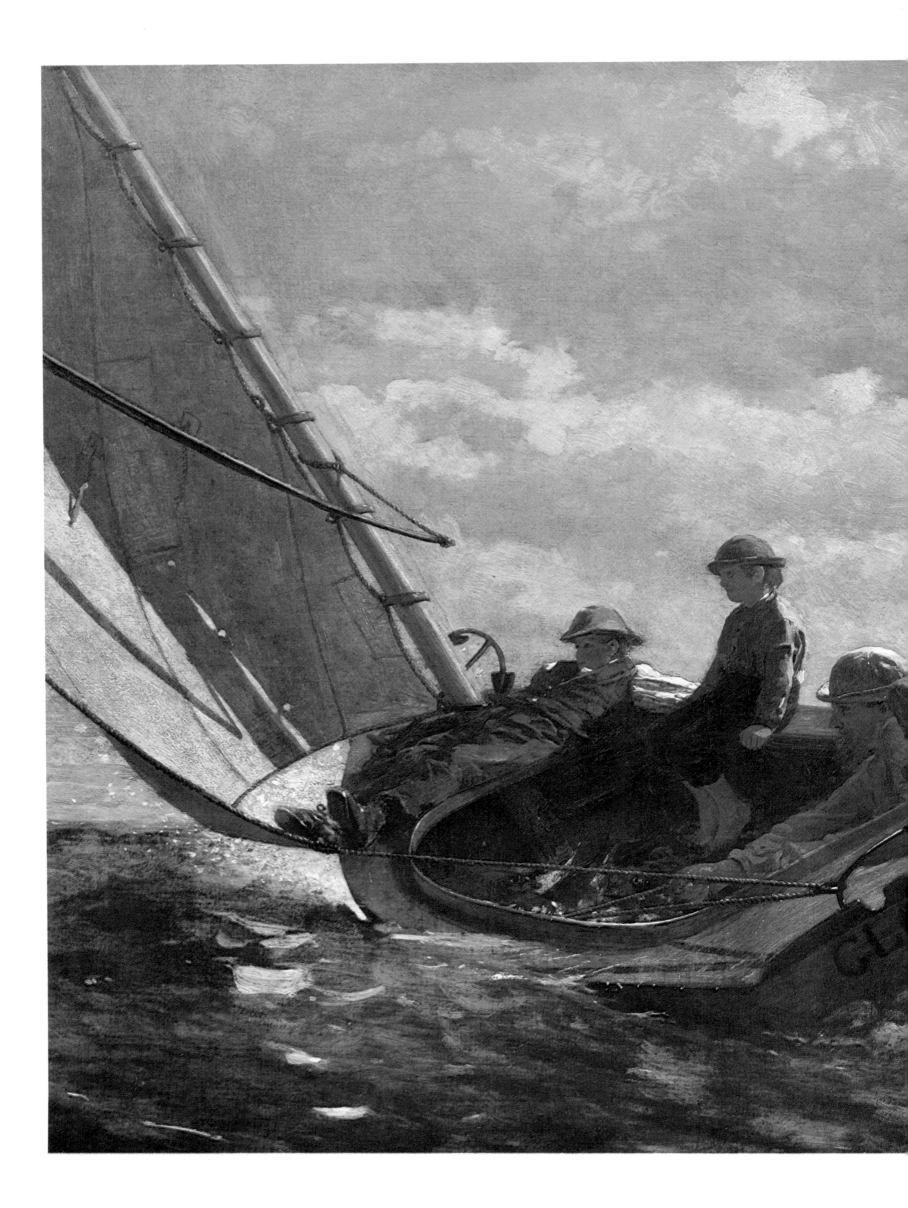

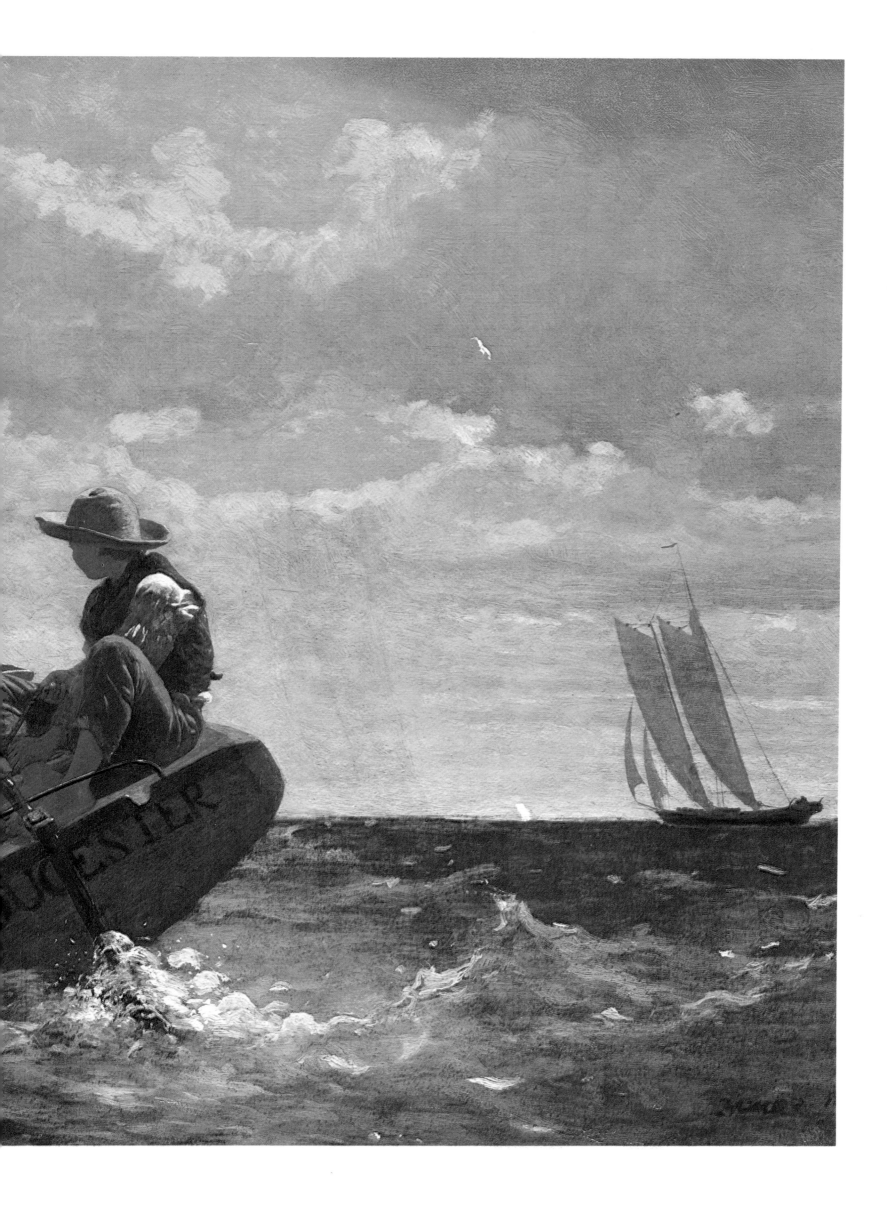

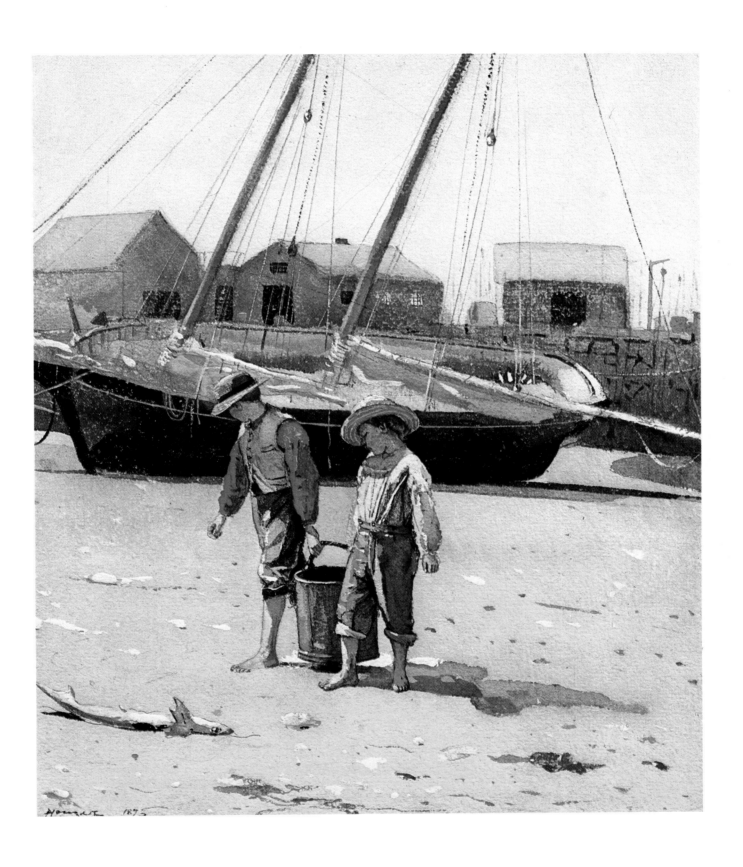

IX. HARK! THE LARK (1882)
Oil on canvas. 36 in. x 31 in.
Layton Art Gallery Collection, Milwaukee Art Center

It may never be known exactly why Homer left in 1881 to live for nearly two years on the North Sea coast of England. Intensely private, the artist never divulged autobiographical details. Whatever the reasons for his stay in Tynemouth, it resulted in a marked, though temporary, change in his style and subject matter.

Gone are the fashionable, pleasure-seeking young women of his lively American genre scenes. They are replaced by stolidly handsome women such as these, who do their share of the rough work of fishing villages, who pace the stormy shore watching for the return of loved ones. Homer's skies and seas are now darkened and troubled, his figures less linear, his colors less brilliant.

The three figures here, undifferentiated in features or in function, are linked together by the exactly repeated diagonal position of their arms. This artificiality of pose may result from the fact that the usually independent artist for once made conscious use of prevailing vogues in English painting. That influence may also account for the overlay of sentiment so uncharacteristic of Homer, and for the necessity of clarifying the meaning of the canvas with a rather literary title.

X. THE HERRING NET (1885)
Oil on canvas. 30¼ in. x 48½ in.
Art Institute of Chicago
(Mr. and Mrs. Martin A. Ryerson Collection)

Back from England, Homer settled permanently on the Maine coast and from about 1884 on turned his attention primarily to marine paintings. At first his canvases show the struggle of men who earn their living by the sea—for example, this composition showing men hauling their catch aboard before fog or heavy seas overwhelms them.

All attention is centered directly on the action. Incidentals have been eliminated; the background is obscured, the figures reduced to shadowed forms silhouetted against the sky. In contrast to the somber tones of boat and oilskins and the generalized forms of the sailors, the fish—the object of this hard and dangerous labor—are clearly, meticulously painted. As they struggle to escape, the iridescence of their scales is picked up in the patch of light that plays over the water; the red of their gills echoes the red of the float attached to the net.

XI. THE LIFE LINE (1884)
Oil on canvas. 28¾ in. x 44⅝ in.
Philadelphia Museum of Art
(The William L. Elkins Collection)

In contrast to the painting above, here a human life is directly threatened by the sea and literally hangs in the balance. With his characteristic avoidance of sentimentality, Homer has given a realistic, dispassionate record of a lifesaving technique then in use on the English and American coasts. By various means he achieves his effects of conviction and vigor. The sail of the wrecked ship, barely visible at the left, and the rocky shore obscured by surf and spray do not distract the eye from the heroic drama. Two interlocking triangles define the center of that action. One is composed of the dangling right arm of the rescued woman, her head, and her fluttering shawl; the other is formed by the support and ropes of the breeches buoy that suspends her over the waves.

Much comment has been devoted to the significance of the shawl. Its blood-red color, starkly in contrast to the prevailing austere tonality, suggests the alternative to this rescue attempt. Beyond that, because it obscures the rescuer's face, the drama is made at once more anonymous and compelling. Unlike his contemporaries, Homer avoids sentimental details in his narrative painting and thus is able to create abstraction from realism.

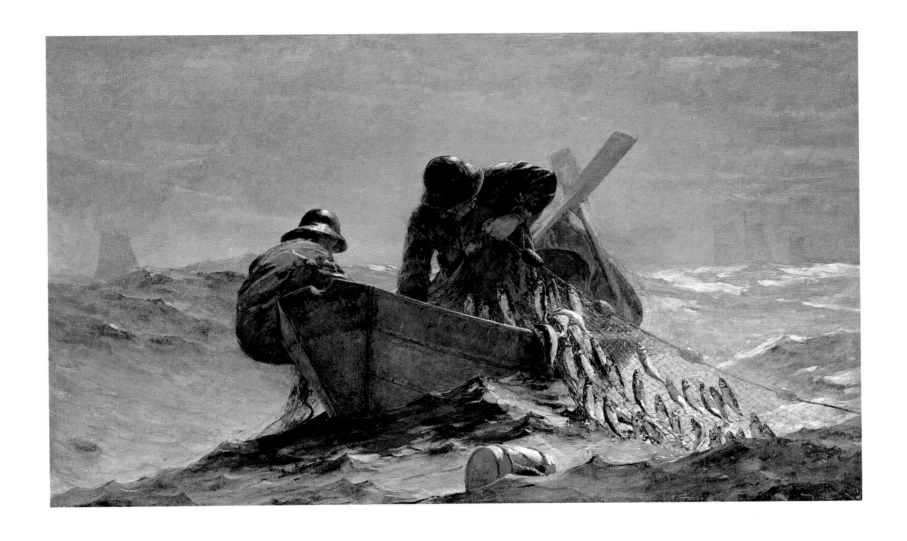

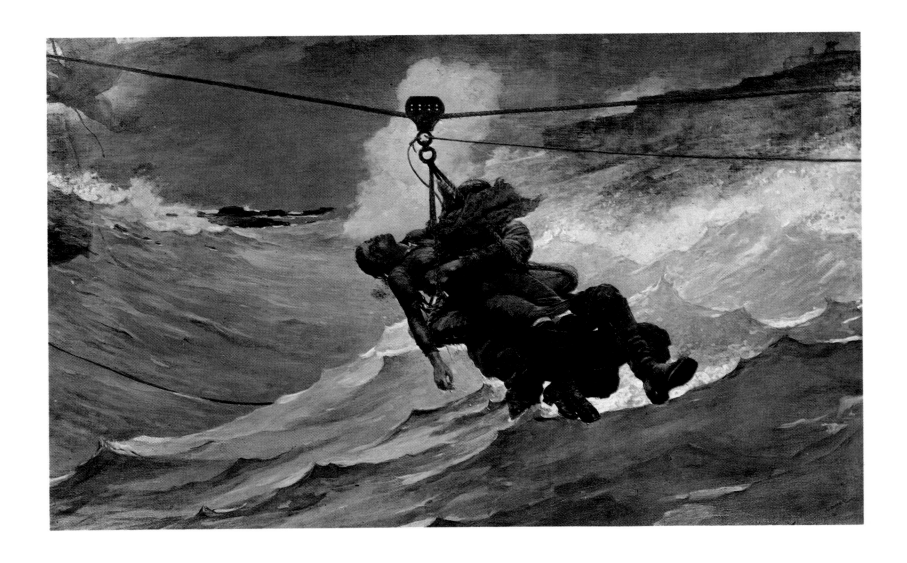

XII. THE FOX HUNT (1893)
Oil on canvas. 38 in. x 68 in.
Pennsylvania Academy of the Fine Arts, Philadelphia

The beauty and the stark cruelty of nature are equally the subjects of this magnificent painting. The fox, floundering in deep snow, is about to be attacked by crows. For once the hunter has become the hunted. With a narrow range of colors, Homer has managed some marvellously subtle effects. The texture of the animal's russet fur contrasts with the dry reddish stalks of dune grass, and is poignantly echoed in the berries at left, like small drops of blood on the snow. The blue-green of the winter ocean is intermediate between the cold blue sky and the faint shadows on the snow, darker under the fox's belly.

This, like so many of Homer's works, seems to show the influence of Japanese prints: the uncluttered composition; the silhouetted forms seen at unexpected angles and cut off abruptly; the stylized effect of spray dashing off the rocks at the left; even the convention of incorporating the artist's signature into the design.

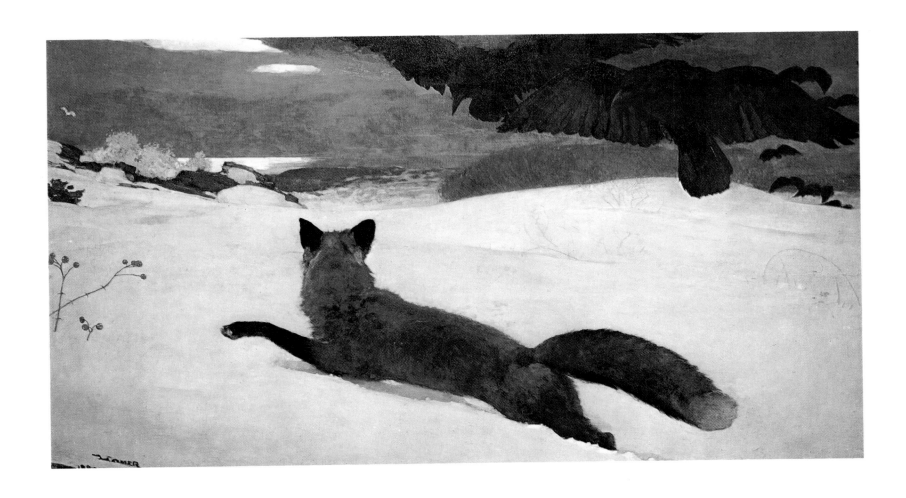

XIII–XIV. THE GULF STREAM (1899)
Oil on canvas. 28 in. x 49 in.
Metropolitan Museum of Art, New York
(Wolfe Fund)

Of all Homer's later paintings of men facing the dangers of the sea, this is the culminating masterpiece. Characteristically, a few significant details—sheared-off mast, bright red flecks on the water, the thrashing sharks—build a story which the viewer is invited to end. An extra twist is provided by the ironic contrast between the grim story and its idyllic setting, Homer's beloved Florida Keys. The warm, sunny water with its rich play of blues and greens has been powerfully painted in thick, rhythmic strokes; the realistic bodies of the sharks are the result of Homer's many hours of fascinated observation.

As in many other canvases, such as *Breezing Up* (Plate VI–VII), the boat is canted sharply, forming a diagonal that should pull the observer directly into the picture. But the abandoned Black sailor is cut off from us by the menace churning up the dark waves in the foreground. Threatened also by a waterspout behind him and with no apparent hope of rescue by the ship far off on the horizon, he is completely isolated. Stoically, dazedly, he faces away from his danger, seeming thus to embody man's will to endure against the most terrible odds.

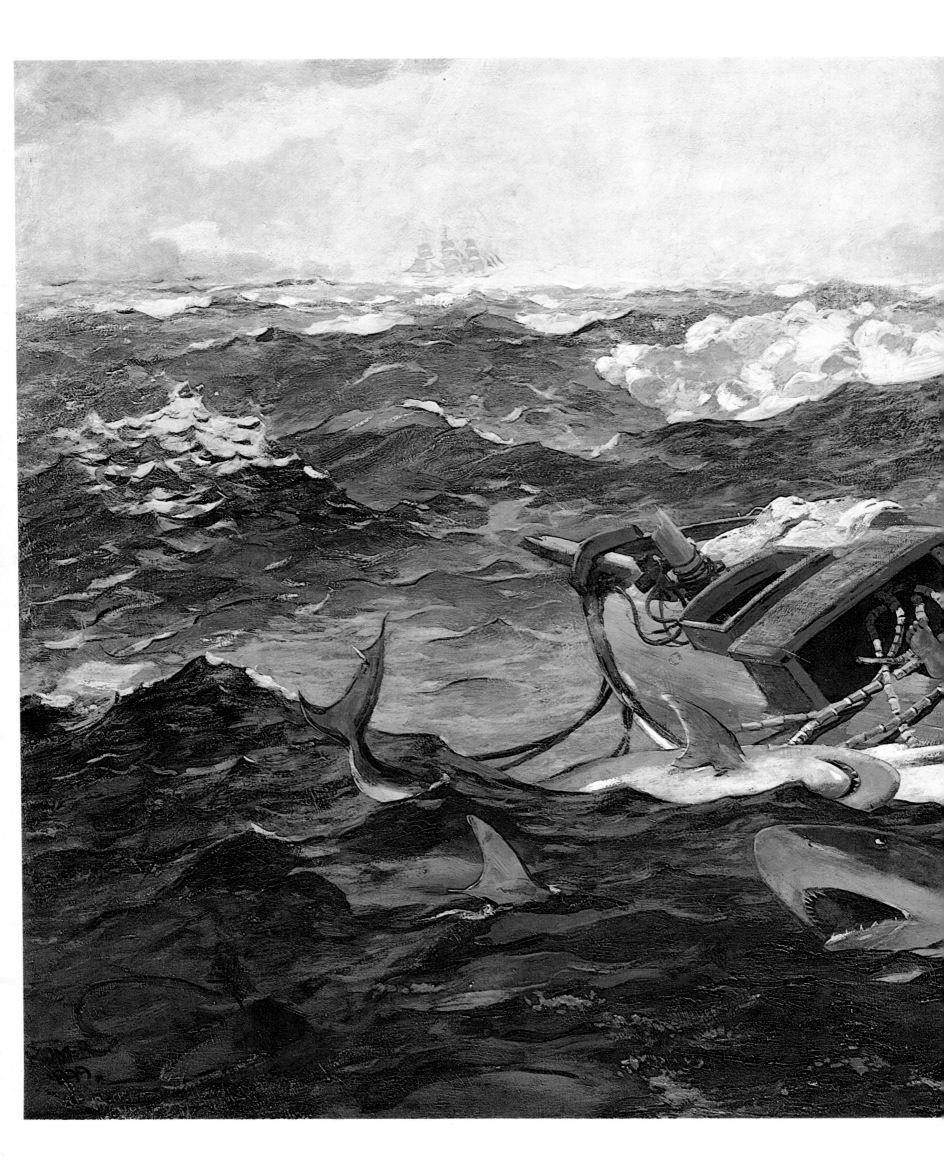

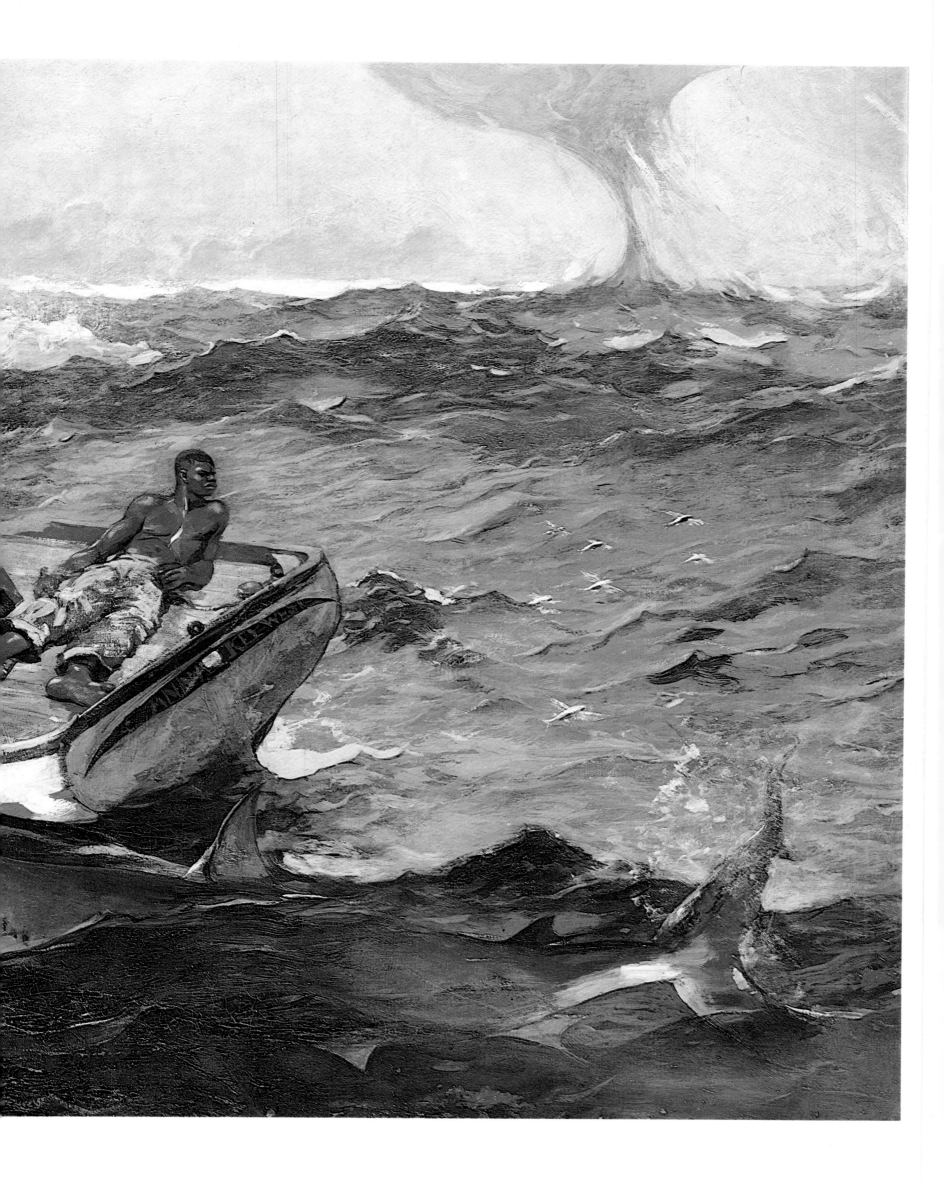

XVI. ADIRONDACK GUIDE (1894)
Watercolor. 15 in. x 21¼ in.
Museum of Fine Arts, Boston
(Warren Collection)

As beguiled by the shadowy forest scenery of the North as he was by the tropical brilliance of the West Indies and Florida, Homer has left us in his watercolors a splendid record of unspoiled natural beauty in all its variety. The limpid surface of this mountain lake is unbroken by the feathered oars which form a strong horizontal dividing water from shore. Tree and reflection seem one, just as the tiny water lily and its diminutive reflection are one. Like the gnarled tree branches, the curved torso of the old guide speaks of solid strength, and his backward gaze brings the viewer immediately into his presence.

Homer's assured mastery of a medium notoriously difficult to control is shown in his broad, loose washes and the cool, subdued colors which perfectly capture the texture of the northern setting. Particularly effective is so small a touch as the way he captures light glancing up from the boat and casting its glimmer on the brim of the guide's hat.

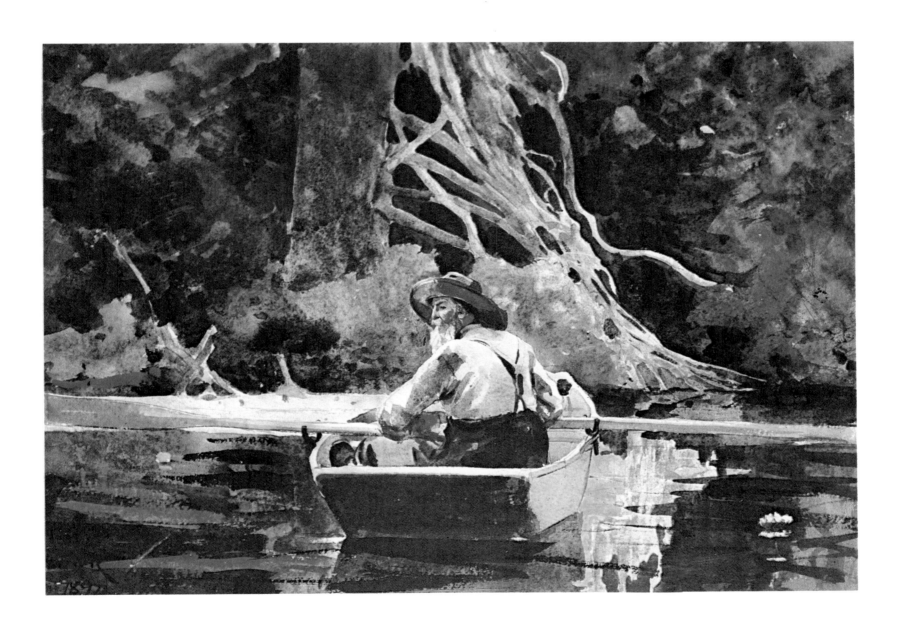

XVIII. KISSING THE MOON (1904)

Oil on canvas. 30 in. x 39½ in.
Addison Gallery of American Art
Phillips Academy, Andover, Mass.
(Candace C. Stimson Bequest)

There is a dreamlike quality to this painting in the way it combines real and abstract elements. Homer almost never did portraits, yet the features of the man wearing hunting attire are based on those of his nephew Charles. With him are two anonymous figures clad in oilskins. Motionless, silent, the three men ride out the storm together but remain locked impassively in their separate musings—like the watchful youngsters in *Breezing Up* (Plate VI–VII). Presumably these men are in a boat; why, or what they are doing, is not revealed. Adding to the sense of mystery, or portent, the ghost of the rising moon contends with the faint glow of the setting sun.

Strong colors, applied with slashing brush strokes, mold the waves. The commanding quality of the painter's mature technique is combined with his lifelong awareness of Oriental prints, shown in the oblique, abruptly cropped design, the composition stripped to essentials. Homer once gave it as his opinion that more than two waves in a painting was 'fussy.' As if in literal illustration of this maxim, the rowboat here is hidden in the trough of two waves.

XIX. RIGHT AND LEFT (1909)

Oil on canvas. 28¼ in. x 48½ in.
National Gallery of Art, Washington, D.C.
(Gift of Avalon Foundation)

Painted a year before his death, this picture is one of Homer's most original and modern. While it looks back to the scientific realism of Audubon's bird paintings, it also reflects Homer's fascination with the instantaneity of the photograph; it even seems to anticipate the stop action shot often used in motion picture photography for dramatic effect.

Over the indeterminately painted sea two ducks echo in their flight the rise and fall of the waves beneath them. One duck is frozen in motion as it begins to rise, the other as it starts its death plunge. There is no sign of the shooting other than the flash from the shotgun far below, and the single white feather at the far right—mute evidence of slaughter. The extraordinary perspective places the viewer at the level of the ducks themselves, creating an intriguing ambiguity of meaning: are we intended to identify with the birds or with those who shoot them? Instead of the pure pleasure usually afforded by Homer's forthright narrative style, we find in this abstract and philosophical painting lingering questions about life and death and the fine line that separates them.

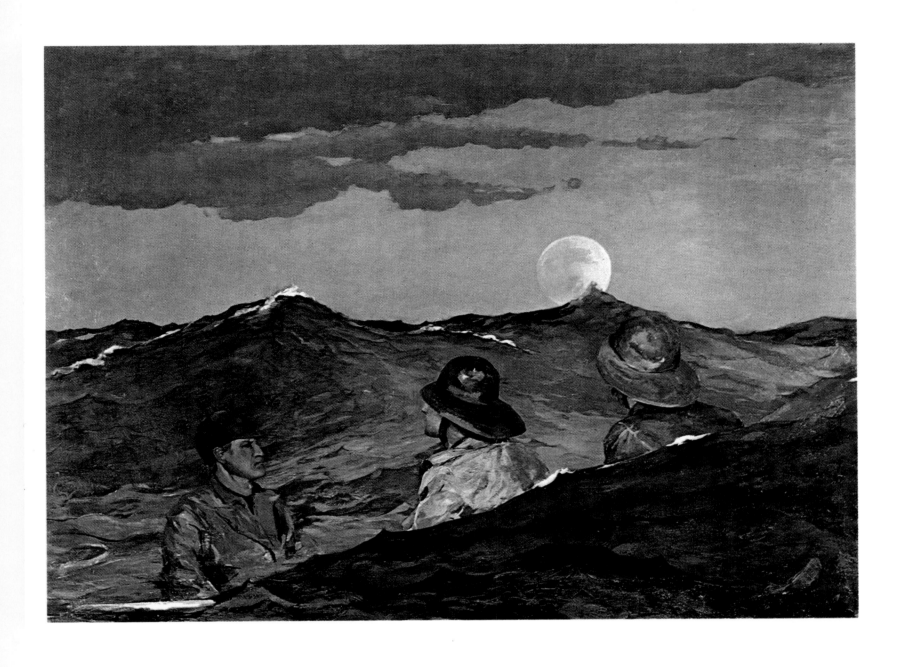

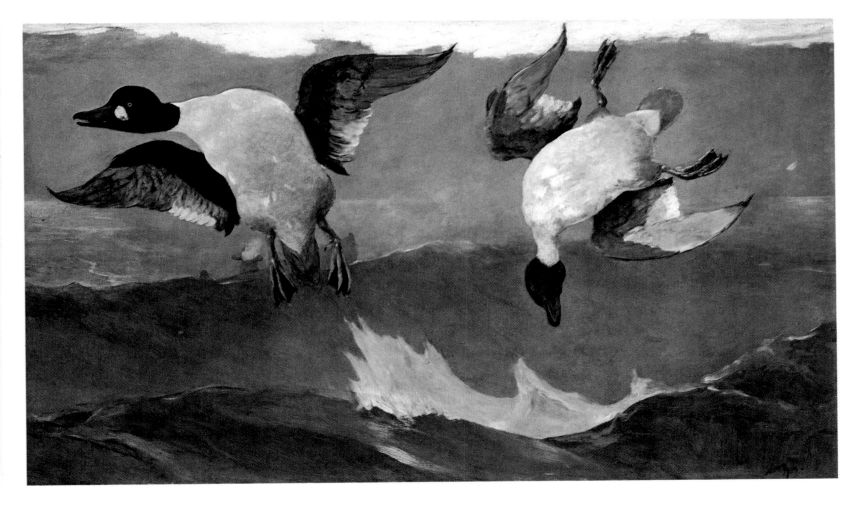